CHAINSAW

SCULPTOR

Folk Art and Artists Series
Michael Owen Jones
General Editor

Books in this series focus on the work of informally trained or self-taught artists rooted in ethnic, racial, occupational, or regional traditions. Authors explore the influence of artists' experiences and aesthetic values upon the art they create, the process of creation, and the cultural traditions that served as inspiration or personal resource. The wide range of art forms featured in this series reveals the importance of aesthetic expression in our daily lives and gives striking testimony to the richness and vitality of art and tradition in the modern world.

CHAINSAW SCULPTOR

THE ART OF J. CHESTER "SKIP" ARMSTRONG

Sharon R. Sherman

University Press of Mississippi Jackson

This book is dedicated to the Michaels in my life: my father, Michael A. Sherman (1914–1963), who has always shaped my future; and my son, Michael S. Zibelman (1979–), who carries that future forward.

Photo credits: Susan Estep, plates 8, 10, 12, 19-22, 28-31, 37, 39, 41, pp. 16, 17, 19, 20, 21, 24; Melinda Hoder, plates 7, 9, 15, 18, 23, 26, p. 6; Sharon Sherman, plates 13, 38, 40, 42, 43, p. 7; Mike Houska, plates 1-3, 16, 17, 35; Pat Pollard, plates 4, 33, 34; J. Chester Armstrong, plates 5, 11; Melissa Ward, plates 14, 24, p. 27; Child's Photography Studio, plate 36; Erik Dolson, plate 25; Kathy Goodwin, p. 34; Nancy Orem, plate 27; Al Wadle, plate 32.

Library of Congress Cataloging-in-Publication Data

Sherman, Sharon, 1943-
 Chainsaw sculptor: the art of J. Chester "Skip" Armstrong / Sharon R. Sherman.
 p. cm.—(Folk art and artists series)
 ISBN 0-87805-740-4 (cloth).–ISBN 0-87805-741-2 (pbk.)
 1. Armstrong, Skip–Criticism and interpreta-tion. 2. Animal sculpture–Oregon. 3. Wood-carving–Oregon. 4. Folk art–Oregon.
 I. Armstrong, Skip. II. Title. III. Series.
 NK9798.A75S48 1995 94-37713
 730'.92–dc20 CIP

British Cataloging-in-Publication data available

CONTENTS

Preface 5

The Art of J. Chester Armstrong 9

References 36

Color Plates 37

As A FOLKLORIST I became excited about conducting fieldwork with J. Chester "Skip" Armstrong from the moment I met him. Here was an artist who created magnificent sculptures of wild animals, who could talk about his personal aesthetics, and whose work answered some of the questions I had regarding how folk art is defined.

In 1985, I was about to host a summer program sponsored by the United States Information Service. Scholars and journalists from all over the world were selected to tour the United States in groups of twelve to fifteen. This group, whose tour focused on regional and ethnic culture, travelled to several locations around the country, including Eugene, Oregon. From Eugene, the folklorists at the University of Oregon organized a tour of different parts of the state and visits with folk artists or literary figures, such as author Ken Kesey at his cabin on the Oregon coast.

The Folklore Program had successfully hosted two previous tours and was now planning for the next. I confided to Susan Estep, one of my graduate students, that I had no contact for central or eastern Oregon and thought that a trip over the Cascade Mountains should not be missed by the visitors. At that point, she asked if I might like to look at photos of her husband's work and consider a sojourn to their home and Skip's workshop. I knew

that Susan was married to a man whom she had described as an intriguing and passionate artist, but I only learned what he created when I saw the photos of his spectacular work. "He's a chainsaw artist," she remarked, and I sensed that he would be a stimulating person for the group to meet. What would represent Oregon and its association with the green forested wilderness better than one who created art from logs with a tool commonly used to cut wood?

After travelling over the scenic mountain pass, the visitors alighted from vans, breathed the clear air of this elevation, and found themselves in a magical setting. In the midst of a clearing in the tall ponderosa pines, a house towered high in the sky, a pond was in a rough stage of development, and a workshop made itself known in the distance by the high-pitched whine of a chainsaw.

Susan greeted the guests, all of whom were awed by the surroundings, and guided us through a tangle of junk cars, old tires, and scattered logs on the path leading through the trees to Skip's workshop. Skip welcomed the group warmly, asking where people were from. He then demonstrated how a piece was made, beginning with a raw log and taking it through enough steps to indicate what animal would emerge from the wood. His ability to verbalize what he saw and thought as he

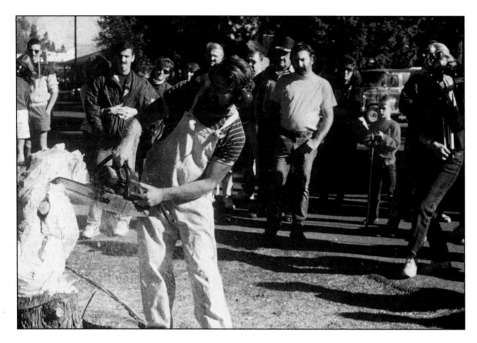

The author shooting video-tape for *Spirits in the Wood* as Skip Armstrong carves a bear out of pine at the Sisters Harvest Fair, 1989.

worked on the log, combined with the mesmerizing image of the chips of wood flying through the air as the piece material-ized, prompted me to think in terms of a video documenting this man and his art. After the demonstration, as some people climbed the five stories of the house to see the view and others sipped tea, I spoke to Skip about the possibility of shooting a video about him. He was flattered and pleased, and we agreed to begin shooting that winter when he would be at a creative peak busily preparing for an annual Christmas gallery showing. Thus began a collaborative project that would stretch over a six-year period.

The video project started with docu-menting the creation of one piece from beginning to end, an approach that I believed was essential because it would focus on process, not product; it was a method I had followed successfully in an earlier film on material culture (*Kathleen Ware, Quiltmaker,* 1979). That first winter I learned that Skip worked in almost any weather and had an unbelievable drive. He literally worked from morning till night, with a brief break for lunch, finally return-ing to the house as the daylight disap-peared. Despite the snow on the ground,

occasional flurries, and the biting cold, Skip pushed himself. I, on the other hand, confess that the air left me chilled; I found the wintry weather (much colder than in the valley where I live) difficult to ignore. With the camera, I followed Skip's process, while my husband, Steven Zibelman, recorded the sound. From a log of English walnut plucked from a pile on the floor of his land, Skip produced a coyote howling in the air. During the same visit, we recorded Skip working on various other pieces in the shop and also videotaped some location footage, including panorama shots precariously taken from the fifty-five-foot-high roof of the house.

One summer we shot Skip demonstrating his work twenty miles away from his house in Drake Park in Bend, Oregon, for a central Oregon arts festival. In the fall of 1989, we taped Skip performing at a crafts market event in a park in Sisters, Oregon, five miles from his home. Friends and neighbors stopped by and joked with him. At this show, Skip displayed his usual animal pieces and a set of magnificent dragon doors. On another occasion, my husband and I followed Skip to the homes of customers who had purchased his art, including the person who now had the dragon doors installed in the entry of his new house (plates 22 and 23). In the heat of summer, with a temperature of 120

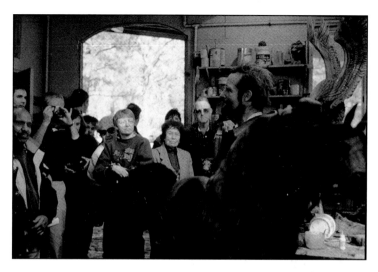

Skip talks to visiting folklorists amid pieces in various stages of completion. October, 1993.

degrees, we videotaped a number of individual pieces inside the workshop. Interviews with Susan and with Skip's good friend, Dave Goodwin, occupied most of another visit. In the winter of 1989, we videotaped a birthday party for Chelsea (one of Skip's daughters), and Skip carving an ice sculpture at a party. For the 1993 American Folklore Society meeting in Eugene, we arranged a preconference tour to Skip's home. Most important, we interviewed Skip at great length in his home.

Portions of the text of this book have appeared previously in the completed videotape, *Spirits in the Wood: The Chainsaw Art of Skip Armstrong* (1991). This book is derived from that work and from other material gathered during our many visits with Skip Armstrong.

My deepest thanks go to Skip Armstrong for inspiring this work and for generously sharing his artistic visions and aesthetic principles. To his wife, Susan Estep, I owe a great debt for photographic materials. And I thank them both for their ongoing willingness to let me invade their privacy and share their thoughts and for their hospitality over a long stretch of time. I am grateful to Skip's and Susan's friends, especially Dave Goodwin, for sharing their experiences with Skip and welcoming me into their homes. My appreciation goes to my husband and soundman, Steven Zibelman, for tape-recording portions of the material and for always intuitively knowing what the pivotal questions were. I thank Letty Fotta for immeasurable secretarial support. Finally, I wish to thank Michael Owen Jones, the editor of this series, who encouraged my own creative process by saying, "Now that you've made the movie, write the book."

OREGON HAS a romantic and well-earned mystique as one of the last bastions of the western frontier. The new Eden at the end of the overland trail, Oregon still summons up seductive dreams of an earthly paradise set within the last pristine wilderness. An eagle traveling east from the Pacific Ocean would cross a rugged shoreline and the coastal mountain range to arrive in the Willamette Valley, a fertile area where the majority of Oregonians live in small cities that are more like towns. At the northern end of the valley lies Portland, the major urban center in the state. As the eagle continues across the Cascade mountain range that makes up the eastern boundary of the valley, it emerges in central Oregon, and the verdant Douglas fir of the Cascades gives way to ponderosa pine and juniper trees. At the end of the old McKenzie Pass, cutting through the Cascades at the midpoint of the state, lies the town of Sisters, which still maintains its western quality. Here, where the mountains, the forest, and the desert meet, chainsaw artist Skip Armstrong captures the spirit of the eagle, sculpting its likeness out of a block of wood. The link between the environment and its people is a defining characteristic of the Pacific Northwest. For Skip Armstrong, the environment furnishes a peaceful space, inspires the imagination, and yields the material for the creative process:

Oregon is really a pretty special place. I think in a way I do what I do because I live in Oregon. I mean Oregon is very much a vital part of this sculpt thing. Wood is inherently Oregon, we have a wood culture here, chainsaws are part of our everyday events. . . .

There's a real individualistic quality to the people that I'm tied into, too. I feel very close to that individualism, rugged individualism, that Oregon represents. You know, the last of the pioneer spirit is still here. . . .

And then central Oregon . . . it's high desert, it's dry, it's a hardy, harsh environment. There's a real sense of earth purity here which is what I try to convey in the work that I do. So Oregon and I are very close. It's a sympathetic, symbiotic touching. I certainly couldn't do this in L. A.

Eagles are Skip Armstrong's signature pieces. Made of black walnut, the eagles appear with open beaks, intricately carved and widespread wings, and talons set to catch their prey. The wings have such life-like feathers that they belie their chainsaw creation (plate 4). Most striking, perhaps, is the eagle's eye, which seems to emit a presence. This is not the wooden, stiff, block-like form one might expect in an eagle carved with a chainsaw. Armstrong's eagles swoop upon salmon, make eye contact as they gaze directly at the observer, or fly in a paired mating duet.

THE
ART OF
J. CHESTER
ARMSTRONG

Among Skip's most popular, most expensive, and most difficult pieces to make, the eagles appear throughout central Oregon. They grace the Redmond Airport as bronzed creatures fighting for a salmon (plate 29); they fly at the entrance to the Cascade Meadows Ranch; and they reside in private homes in Sisters, Oregon. I asked Skip about his inspiration for the eagle figures and whether he saw them out here.

No, the eagles came from a road trip I did up into the Alaskan panhandle, where they're just like seagulls. And I . . . I spent weeks up there just watching 'em dive and swoop and eat the salmon runs, fight for territory and squabble. . . . I'd camp right there on the beach where the inlet came in, where the salmon were running.

I asked him if that was why a lot of them were grasping salmon.

Yes. I mean I saw the dive, that talons-out dive, and to me that captured what I thought about the eagle. . . . The eagle is a soarer, too. And I do them as soarers. But . . . to me they're also the . . . sky-high predator. I put a lot of detail into the eagles. . . . I want that thing to jump out at you. I want that, that excitement of connecting with a wild animal to be seen in the piece (plates 1, 2, 3, 4, 7).

That connection with the animals gives life to Skip's work and Pacific Northwest animals serve as his primary subjects. Working in the tradition of realism, he makes the cougars, coyotes, otters, whales, and horses seem ready to breathe, to spring to life. Skip doesn't find it unusual that the pieces convey the presence of a spirit:

I am an animal. I mean I see myself with them, not on another plane. So when I'm sculpting the horse, let's say, or the otter, I'm feeling in myself the feeling of what that horse or otter is to me.

Susan Estep, Skip's wife, asked during the course of a long videotaped interview session if he had "been there with those animals?"

Well, I try to, as much as I can, have personal references to everything that I sculpt, that it isn't just a, an abstract picture or concept. I've hiked and backpacked extensively in Alaska, and I've been chased by grizzly bears.

Known to the art world as J. Chester Armstrong and to his friends, family, and local Sisters neighbors as "Skip," Armstrong has lived in Oregon and worked as a chainsaw sculptor for over twenty years. Like the animals he carves, Skip is supercharged. He works and speaks with the intensity of one who is inspired, and his power seems boundless:

I feel that there's an energy charge in me. . . . I feel like I'm part of the

elemental forces, let's say, that this world has in it. I'm tapped into those forces. Like the wind is a force, you know, the wave action of the ocean is a force. The human tied into that can become, himself or herself, a force. There's an elemental earth force energy that's working through me.

I think, over time, you build up a reserve of images, of ideas, of ability to execute those ideas, a belief in yourself builds up and taken all together there's a point where all of those things coalesce and you suddenly become an explosive force of energy that can basically do anything.

Skip is a robust representative of the Northwest. Both his physical and artistic presence evoke a sense of awe. Slightly under six feet tall, he is remarkably strong and is able to move logs and wield the chainsaw for hours on end. With boyish good looks, he projects the image of the rugged western man, surrounded by nature and living in an isolated part of the woods. Although he represents the romanticism of the nineteenth century, his well-articulated intellectual philosophical discourse on the environment suggests a forward-thinking man for the twenty-first century. One of those rare magnetic persons whose artistic depth and fervor is spellbinding, Skip is, above all, charismatic.

Becoming an Artist

As is often the case with artistic vocations, Skip's initiation into what would be his life's work happened serendipitously. Skip grew up in Berkeley, California. As a child, he enjoyed drawing, but there was no evidence that he would pursue any form of art as a career. At the University of California, Skip did not study art beyond the great figures in history, such as Michelangelo. He graduated with a major in philosophy, which perhaps explains his search for the underlying meaning of existence and his interest in bringing to life the spirits that he sees in the wood.

Skip's mother was an avid collector of wooden carvings from around the world. He commented to me, "There's a folk art wood carving tradition that's alive and well, and I grew up with it." He credits his mother for his feeling for wood. "As a kid, I would study these things, and marvel at them. How could someone make out of a block of wood these little items that look like, for example, a frog? I mean I was intrigued." His interest led him to the childhood pursuit of whittling, and he recalls that he earned a wood carving merit badge in the Boy Scouts. For a long while, wood carving was not his major focus, but it was not easily forgotten:

Always, in the back of my mind, I was still intrigued. And I loved it, but it didn't

seem immediately relevant. It was just one of those loves you set aside, and you know you're aware of it. . . . It was speaking to you but you didn't know really what to do with it. And it wasn't till later, you know, when you get back out into the real world, and you . . . you're faced with the whole dilemma of how you're going to make a living and what are *you* going to do in *your* time. And I kept coming back to . . . the wood carvings that I'd seen because there was a real love there and I'd had a real appreciation for wildlife. I grew up Sierra Club—outdoor oriented, backpacking, and I was tied into the animals.

Leaving behind the political upheaval in Berkeley during the tumultuous sixties, Skip began travelling. The introspection engendered by the times, the back-to-the-land movement, and the renewed interest in handmade objects all blended with the natural desire of a young person in his twenties to find his identity. Searching for a place and a sense of self, Skip settled in Vermont:

I wanted to go back to a little town that had a sense of its own history, it had roots, the people knew where they were comin' from and goin' to and, after California, the mayhem of the transient world, it just was a refreshing change. I was seeking little towns with a sense of identity . . . where one could have an identity.

Moving to upstate Vermont, to a town with one store and twelve houses, Skip came to love the quiet. In the winters in northern Vermont, activity slows. Skip sat, hour after hour, drawing and then constructing in clay. He sold a few pieces, and something fired his dormant idea of becoming an artist. It was there that Skip also became acquainted with the chainsaw. As he notes, "I grew up in California. At the age of twenty-one, I didn't know there was such a thing as a chainsaw; I mean it was a complete unknown to me."

To support himself in Vermont, he had to find work. In the process of repairing old barns, he learned to use traditional methods of construction, such as mortise and tenon, and how to work with a number of hand tools, including chisels and adzes. The building process was one of imitation, of reconstructing what had once been a new barn to its former shape. With this accomplishment, he uncovered the structural elements of the barns, discovered the significance of tradition, and found his future:

I came with nothing and I had to figure out what to do and I would work with the farmers around there and I would cut their trees down, clear their fields, and one of the farmers down the road had an old chainsaw that he wasn't using anymore. And I took that chainsaw and I built barns with it, and I cleared fields. It became my everyday companion . . . and I

got really versed with it. I could cut corners and circles and felt pretty good [laughs] about the old chainsaw.

After two and a half years, Armstrong decided to return to the West Coast. "You're tied into the West Coast culture," he remarked. To Armstrong, the West has a sense of movement and freedom. He went to the Pacific Northwest where he took a job at Spirit Lake next to Mount St. Helens in Washington state (a site famous for its beauty and its eventual devastation by a volcanic eruption in 1980). Here, the chainsaw would trigger Armstrong's artistic breakthrough and become a creative tool:

And I left Vermont and . . . I came back West and I got a job as a YMCA camp director and . . . I had to make up a program. When you're a camp director you get to make up the program that you love to do and . . . I wanted to introduce the kids to wood carving. "Perfect opportunity," I said, "I'll teach the kids and teach myself at the same time." And Northwest Indians were . . . the focus. We were in the Northwest in Washington. So we started doing totem poles together as a group—the kids and I.

The chainsaw came secondarily when the kids just didn't have the attention span to handle carvin' out a big totem pole and then [snaps fingers], it occurred to me that this chainsaw would speed it

up to the point where the kids could get excited again.

Skip knew that others were using the chainsaw as an artistic tool, and this stage was the beginning of his own carving with a chainsaw. The camp gave him the opening to put the skill he had acquired in Vermont to a different use:

We had chainsaws, we had big trees, so we taught the kids how to carve wood . . . wooden totem poles. I'd rough 'em out and the kids would finish 'em. And I loved it so much that at the end of the summer, when the kids left, I just kept goin' at it. And that was the beginning (plates 5 and 6).

Whereas Skip had lived in relative isolation in Vermont, he was now in total isolation. Soon, the animals became significant as companions, and Skip established a connection with them. The cougars, otters, bears, and elk made themselves known:

I was really part of a very natural scene up there and I tried to depict it in wood. And as things go, I ended up getting fairly good at it. I had a perfect context—I was alone, no real stresses from the outside world. I could really just focus on that. And the irony is that at the end of my time there, when the snow started to fall, and I had to leave the camp, I loaded up this boatload—you had to go in and out by boat—I loaded up a boatload full of the sculptures that I'd done in the

couple of months I'd been there. And on the other side I created a real sensation when I docked and unloaded these things in the parking lot. I remember it to this day—that people gathered around, oohing and ahhing. And then somebody popped the big question of how much, "How much is that? How much is that?" I was making, at the time, fifteen dollars a week which was, you know, the basic wage. And so I thought, "Well, I'll take a real chance here. I'll tell 'em fifty dollars." You know, it's the big time. And they bought that one and somebody else said, "Well, how much is that one?" and I made up another figure for that. So I sold a number of them right there on the spot and I ended up with three hundred dollars in my pocket, and I thought this was the new world, this would work.

While at the camp, Skip not only discovered what was to be his life's work, but he also realized the artistic principles that would guide his process. Observing the otters at the lake, he began to move away from the linear pattern of the totem pole, a form that follows the straight lines of the log. Upon deciding to sculpt otters, Skip began to work at using the wood to create the shapes he saw:

At some point, well, the point was otters, I remember otters particularly, they're real sensuous and curvy little guys, lot of spark and energy in 'em. Lot of rhythm and movement, if you've ever seen an otter move, in the water or on the land.

I lived with them on the lake. I'd sleep right down on the docks and they'd play every morning underneath my bed. And I just felt the charisma, the connection with these little otters was just . . . right there. And so I decided, after the totem pole era, that I wanted to sculpt these otters, these really meant something to me, they were a special animal. And in order to sculpt an otter you have to discover the curve, and the curve was the revolution. I suddenly was aware that you could take this block of wood and create curved space and not just straight lines in it. And I made otters . . . (plate 9).

Community

After leaving Spirit Lake, Skip travelled throughout the Northwest. Arriving from a land of open desert and junipers on the east, Skip saw the forests starting at the town of Sisters, Oregon. Here, Skip came to the end of his search for a small town that would meet his needs. Susan explained that Sisters combines the rewards of small-town life with their desire to live in an isolated area:

It really helps to be outside the city limits . . . to have the silence and the space of a country area, to be able to

unfold your own spirit and your own creative process, whatever that might be. . . . And yet we're still in close proximity to the town . . . and we're an integral part of that town. . . . We have a lot of really close friends. You go to the post office, you know the people there; you go to the store, you know the people there; you walk down the street, you know people. It's like being in one big family in a way . . . that's a lot of the reason we're here. It's just a tight little community. . . . The other reason is the natural environment . . . the mountains are real significant factors in both of our lives . . . [plate 43]. We can tie into those mountains and see the weather or the day moving in or the day moving out. It's just part of what really makes us appreciate the area. And there are very strong presences in those mountains. . . . [Skip] fell in love with the area . . . I had the same feeling of just entering into this paradise. . . . It's beautiful here.

Skip bought land five miles from town, built a sparse shack, and began sculpting. Beginning on a small scale, he worked before amazed onlookers on the main street of town. Skip's friend, Dave Goodwin, remembers when Skip first started: "He's been doin' this now about fifteen years in Sisters. . . . He did it up across where the hotel is now, Sisters Hotel—was an old Shell station and a bunch of shade trees. I don't know if you're familiar with that. But at that time, the tourists would come and watch him work and it was kind of an attraction fifteen years ago in Sisters . . . so he's been here a long time and everybody likes him. He's very popular in the community."

This pre-studio public performance stage is common among chainsaw artists in the West. For some, it is the only stage. Setting up their sculptures along a busy stretch of road, they create on the spot, the chainsaw noise attracting the attention of tourists. Those who sculpt along Pacific Coast Highway (US 101) in Oregon are often referred to, usually with disdain, as "highway" or "coast road" artists. Their art has a "kitsch" quality and the pieces are often made for the sole purpose of selling the public what it wants rather than creating from an inner aesthetic impulse. One coast road artist told me that he had been out of work and had seen others making considerable amounts of money selling chainsaw art. He studied the process by observation and, within a week, he was working on his first piece. The rapid sale of the item convinced him that he had found a new livelihood. Most of these highway pieces have a stiff, linear, block-like look that announces their log origins. In contrast, for Skip, whose pieces demonstrate his ardor and a sense of the animals'

spirits, the process of creativity is the driving force.

Armstrong's reputation is legendary in the West. Most chainsaw artists know about each other. In numerous conversations with them, I discovered no one who had not heard of Skip—"that fellow over there in Sisters." Skip is more than aware of the other chainsaw artists and their methods:

Really what I do with the tool takes it in a totally different direction from the chainsaw sculptor that's working on the coast, let's say. The danger of a genre like chainsaw sculpture is that they all tend to look at one another as the defining factor on what chainsaw sculpture is and so they don't branch off into new directions. They're limited, self-limiting, because they make their [linear] style carving again and again and again and then somebody else sees that and says, "That's what chainsaw sculpture is. I'm going to do that." And he does the same kind of thing, rather than not even looking at any of that and doing really what you want to do from the inside, what feels right.

What do you want to express? You see, the key here is what is it you are trying to express. Are you making an artifact or are you trying to express something that has an inherent soul . . . and the result is radically different.

Skip's evolution as an artist has been fairly swift. Over a six-year period of con-ducting fieldwork with him, I noticed the subtle changes in his art (e.g., horses moving with greater sinew; eagles whose feathers became silky and whose claws now exhibited a startlingly realistic texture), and I commented on it. He responded: "I feel the process is really unfolding quickly. I mean, in a sense, day to day, you might think it's stagnation, but over a period of time there's rapid change in movement and progress. There's growth here" (plates 8, 10, and 11).

Process

Process is at the core of the development. Folklorists who study material culture once focused primarily on the object and its form, design, color, and style. Today, because of theoretical shifts, some folklorists study the creator and the act of creating as well as that which is created (cf. Ferris, Jones, Vlach). This shift in thinking is pivotal because it leads scholars to examine that which the artists themselves find significant:

I like to see where [the pieces] are going to go to rather than have the idea already completed before I start. So process is real important to me . . . it's a discovery process and that's why after twenty years I guess I'm still excited about it . . . that I can still start each new piece as a new piece, and a new challenge, and it's gonna take me some new place.

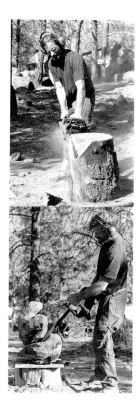

The process of creating an intricate otter piece represents Skip's maturity as an artist. The photos for this page and pages 17, 19, 20, and 21 follow Skip's process. Compare the result with plate 8.

And maybe it doesn't, maybe it takes me someplace I've already been before, but I'm always willing to start the next piece with the idea that it might take me to that next insight, or the next plane that I'm looking for, 'cause I think, in all art, you are looking for your next plane of reference.

Skip starts a piece by selecting the wood from a huge row of big logs. When I first visited him and Susan, small sections of logs were scattered about their land. Skip likes to salvage items that might be useful later. Junk cars, for example, sit here and there in the middle of the trees leading to the workshop. As with the sculptures, an aspect of the act of creating seems to be inherent in these items, which Skip uses for parts in a continuing process of fixing vehicles or keeping the usable ones running. In an old, barely standing garage, an ancient Cadillac is stored for some time in the future when it might be repaired. A portable pizza cart has been salvaged for eventual decorative purposes. Tires are abundant, the tire from one car often replacing that on another. In the midst of this seeming chaos, the wood appears in piles.

Skip used to acquire wood in random ways. Driving the highways and roads, he was always looking for dead trees. When he saw something he wanted, he would find the owner of the land and ask if he

could have or pay for the wood. As his output expanded, he was able to obtain wood in greater quantities, buying some of it from various wood merchants in northern California, an area that has a lot of black walnut, the wood Skip favors for his sculptures:

I've got into big logs now. Collections of big trees. The wood is black walnut primarily—cedar, some juniper, maple, a little oak, so there are a lot of varieties. I think my preference of all woods is black walnut. . . . A fine finished piece of black walnut has a lot of color and depth and has a soul in the wood. And it's a hard wood, it's durable, you can do intricate things with it that you can't do with, for example, a soft wood which would break on you.

Although trees abound on his land, Skip wants them to remain standing; he prefers to use wood that is already dead rather than have trees cut. He believes he is closely connected to the environment and the trees. "They're friends, to me," Skip explained. "I don't want to be cuttin' them down. You know, I live in a forest but I don't want to use those trees." The wood that grows on the land is ponderosa, a wood that does not lend itself well to sculpture because it is soft. He noted, "There are lots of things in woodcarving you have to be aware of. You want durable wood, you want one that is self-sealing, that doesn't split and crack on you after

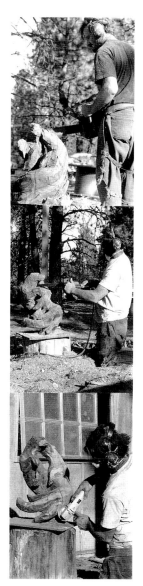

you've put all this labor and energy and inspiration into a piece."

Another wood that grows in central Oregon that Skip does use is juniper: "This is juniper country, it's my reference to the high desert, and juniper's an elegant wood, really a nice orange pattern, got some white in it." English walnut is also available from the nearby Willamette Valley. Occasionally Skip uses pine and some unusual wood such as avocado (plate 12). The type of wood selected is determined by the project. In 10 percent of the time it takes to finish an animal, 90 percent of the wood is removed by the chainsaw. Skip also eliminates 90 percent of the multiple cracks in the wood, removing them as he reduces the block of wood. All of the wood is seasoned.

Skip chooses a log section and rolls it to the site where he wants to set up and work. The first cuts begin the roughing-out stage. The chainsaw moves from cut to cut until a form begins to emerge. For stability, Skip attaches a piece of plywood to the end of the log that sits on the ground. Only the final stages of detailing—smoothing, sanding, and oiling—occur in the workshop. The major work is accomplished outdoors in the heat of summer and the cold of winter.

Often Skip will begin by walking around the log and pondering it for awhile, thinking about what the log might yield. I asked him to explain how this procedure of looking at the log ignited his creative fire:

What's going on is the whole ball game. I mean everything. That's the core beginning. And it's a synthesis of inside, outside. I'm looking, of course, at the block. The block is my initial core beginning. It has a certain height and width. It has a mass to it. I study the rings, the way the circular rings go in the log. There's no a,b,c,d process here, it's a randomness . . . I study the log, I look at it, I might daydream a bit about it, walk away, but at some point in a . . . subliminal method I hit on something that will work in that log. I mean there's a spontaneous connection, and then I start looking at the log a little differently, I start, in my mind, I try to see a little clearer that shape that I see might work in that piece. . . . Just a little glimmer of an idea often is all it takes, just a beginning, that's all I'm looking for, some way of getting into that log.

So that little spark of an idea just lets me start approaching the log, and then I can start blocking in something. I mean, painters have the same problem, the worst thing is a white piece of paper. They have to start doing something with that paper, blocking it in. So my first initial idea is just to allow me to, you know, approach that log and do something with it, start doing something. So I'll start making some cuts. I have that one little seed idea and, as I start to cut and I start

to really deal with the physical mass of that log, the idea starts taking shape, it starts defining itself. . . . Each cut begets another cut, I see from that cut to this cut to this cut, "Oh, yeah, I need to go over here, I need to do this, this is now the piece. Now, ahhh, this is the piece that idea was the seed beginning of." So there's a discovery process going on. I don't start with a clear, clean, total idea. I start with a little seed that develops I'm discovering as I go on what that piece is going to be and look like.

Style and Aesthetics

Skip is in control of the process, but both Skip and the log determine the animal. The log presents what is possible by virtue of its size. In a Zen-like manner, Skip sees himself and a log working together:

It has to be in the wood. I mean, sure, there's an idea in my head, but the piece is in that wood. My idea in the head is random, it scatters out, it has no defining boundaries. Whereas the log, the wood, has a definite defined boundary, so that piece, obviously, has to be in that log, in the circle of that shape.

There's a real symbiotics going on. I mean there's give and take. I've got the seed idea that lets me start seeing the log as a horse, let's say, but then the log shows me how that horse is going to be. The block of wood is really defining how

my idea is gonna take shape. I'm part of the process, but I'm not the whole process.

Skip's pieces contradict their chainsaw origin. When Skip demonstrates his work to others, viewers show their amazement. They immediately see—and hear—the chainsaw, with its blaring din, break through the surface of the log, but the completed pieces with which Skip is often surrounded seem to have little connection to that initial operation. Explaining his methods, Skip evidences his delight at this outcome, and he enjoys watching viewers' reactions. In between the beginning and the end lies Skip's unique creative process expressed through his use of various tools:

When you immediately see me working you think "chainsaw." "This guy is doin' this stuff with a chainsaw." And then you look at the finished piece and you see this bears no relation at all to a chainsaw. What happened? And the fact is, a lot happens. . . . The real essence of the piece is chainsaw art, the finish is something completely different . . . and it entails a whole series of other tools that refine the piece, grind it, shape it, and basically let it twist and turn just exactly the way I think it should. . . . The process begins with the chainsaw, it begins with a big chainsaw . . . I do that to keep my lines and basic shapes simple. With a big saw, you can't get cluttery—you have to

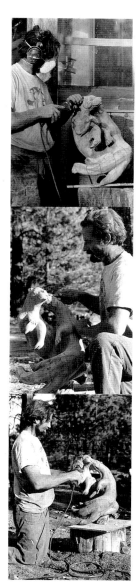

do the whole totality of the piece . . . it forces me to think big and major and so the dominant shape is grasped that way. And then I go to a littler saw and that defines out what that big saw suggested. And then I go to a littler saw again . . . from the littler chainsaw, I go to a grinder that takes what the rough saws have left and smoothes the line in. . . . From the router, I go to littler routers and ultimately I go to air tools. . . .

So, you see, you have a series of shaping tools like the camera focusing— you start with the big picture and you finally start focusing down and bringing into focus . . . what that initial act of the big chainsaw suggested.

As with his use of a simile to relate the tools of a chainsaw sculptor to the tool of a videographer, Skip also expresses how he feels about the process of detailing a piece by comparing himself to a symphony director. He often uses a simile as an effective means of communicating what he does to those to whom he is speaking. (He probably used these images intentionally because he was talking to a filmmaker and to a sound man who is also a musician.)

After we've got that line in, then we work on the nuances of the sculpture, just the things that pop it from being a piece of wood, let's say, into an animation . . . the shape of the eyes, the little detail, the snouts, let's say, the claws—there's an intensity and power that comes out of

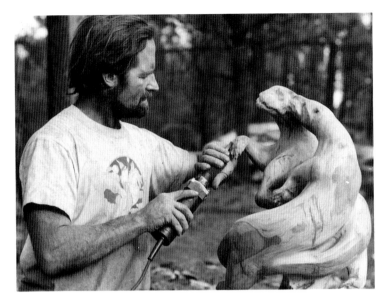

Skip refines the otter piece with a router.

detailing at this point. I call them "accents." You want to hit it heavy here, you want to slide there. It's like a symphony: you want to draw out the flutes and subdue the bass . . . I'm the leader of the symphony here.

To orchestrate this animation, Skip, who takes enormous pleasure in creating on multiple levels, has altered various tools. As he explained to me why he needed to make new tools out of old ones, he demonstrated one of them:

This is the router. It's a dye grinder, electric high speed, 32,000 rpms that moves wood. I've adapted the bits to do what I want them to do. In fact, I've adapted everything. There's nothing that comes standard out of the hardware

20

store anymore in my workshop, they're all modified—modified tools to do modified jobs. In a sense what I am doing I think really defines what man is. We, as humans, are tool users. I mean that's been our final defining characteristic—we use tools. And I get a real sense of fulfillment from that. When I'm in the workshop surrounded with my tools I feel I have become, in a sense, what the human is—the tool user. And I use tools and I adapt tools and change tools in order to do what I need to have them do. So, "man, the tool user"—I like that label.

Perhaps what is most astonishing is the use of power tools for almost the entire process. Even the sanding is accomplished first with a belt sander and then with fine-grit paper on another smaller power sander that Skip has adapted. Only the very final stages are done by hand. A light sanding and ten to twelve coats of Watco oil complete the pieces. Often these end stages are carried out in the workshop by assistants whom Skip initially hired when he needed to have a number of pieces ready for a showing, and who now work for him on a regular basis. The creative intensity soars during the chainsaw execution and detailing; the rest of the process involves the tedious work that is necessary to refine the piece. "Because I find myself tied into the creative processes there's no drudgery involved with it," Skip

remarked. "I'm always out there creating —on the creative edge, and I can give the piece up to somebody else when the creativity no longer is needed."

Activity in the shop intensifies before a show, after which the workshop is empty. "These things go in waves, really," Skip explained. Work slowly begins again until Skip and the others in the shop are working on three or four pieces at once. The pace quickens, and, weeks later, the workshop is full of pieces in various stages of completion (plate 13).

Skip's assistants in the workshop have learned the folk art of chainsaw creation through observation. Folk art is art that is learned informally through imitation and to which an artist adds his or her own innovative signature. Thus, folk art is subjected to variation and change, but it is still identifiable as traditional. Skip's work exhibits this formation and generation. After working with Skip, at least one assistant has branched out on his own. Skip sees this as a natural progression:

Initially, you might think, "Well, hey, that was my idea, you're usin' my idea." If he strictly copies, let's say, there's nothing that ultimately has been gained through that process. So it's important that there's new ground broken and I can learn from people who have learned from me. . . . One of the things I love about sculpting, and specifically wood carving, is that it has been the human task from the

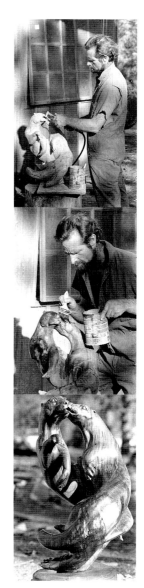

beginning of time. **That as a wood carver and a sculptor . . . I really feel tied into the historical process of art and sculpture. When somebody learns from me, I'm . . . furthering that and doing my part.**

Although he makes references to Michelangelo and Rodin, Skip's own training is informal, like that of the assistants who have learned by watching him. I asked him how he had perfected what he had begun doing with the chainsaw in Vermont, remarking that, while he had no training in art, he was very familiar with what had happened in sculpture work and could speak about sculpture in a very knowledgeable way.

I have had no formal training, it's true. The degree I got was in philosophy and poetic theory and literature. But those are a good ground base for doing anything. And what they taught me was how to learn. And I know how to learn, you go to the source where the knowledge is. For the last twenty years, I've been observing. . . . You gotta start from the core, ground level when you're doing sculpture, and that's the inside muscular tension that makes an animal move and live. So I've done a lot of study but it's all been backyard study. . . . Self-taught.

What Skip has learned results in the abstract and the concrete merging in his work. His emphasis is on the shape, and he focuses on how he might render the lines to create the motion of an animal. His concentration centers on the dominant lines. He explained that he thought of sculpture as "line and form":

The lines are very important to me. A line to me has an inherent rhythm. If it sweeps up, there's a corresponding sweep down. I mean, there's a rhythm to every line and the shape of the piece is determined by what I feel about the shape of that line. You know, I'm not really just doing a "horse." The horse happens to be what the thing looks like, but the shape of the horse is my feeling about the line. I mean, that's radically different from somebody that's just carving a horse, if you can see that. To me the line has reality, not just the fact that it's a horse. The movement's in the line. There's a beauty in a line.

With this primary focus on the line, Skip's creative vision of the animal comes to life. The final piece represents a correspondence to what that animal is. What takes it to another plateau is Skip's interpretation:

Serendipity is in a line and so the grinder allows me to see what that line is and then I can correct where the line needs to be corrected. . . . So, after the dominant lines are drawn in and refined out, basically, the piece starts defining itself more fully.

Skip believes he is "captured by the piece." Creating the pieces has become an artistic adventure and a discipline, too. The connection with the piece is now a perfect blend. The longer he has worked, the better he is "at sustaining that focus." Skip pointed out, "My mind and that piece of work . . . are really one. There's a melting together."

As a man who interprets his own art in clearly thought out discussions, Skip provides the "window" into the parts of the process hidden from view—the inner thoughts shared and reflected against the individual personality of the artist. Some of the questions that puzzle folk art researchers also intrigue Skip, and he has pondered the issues and addresses them directly in analyzing his own experience. For example, is folk art a repetitive process? I believe that the process is never replicable, although each act may bear similarities to other such acts. Skip reinforced this hypothesis in a conversation about the *feeling* of the experience. I asked him whether each time felt different—what it was like making a horse so many times, or sculpting an eagle so many times.

There's a good point—a horse so many times. Yes, it is a horse, but every piece is a unique piece. It isn't just the same repetitive process. . . . The creative process is exciting, even though it's still a horse. There's something about the randomness of—you don't really know exact-

ly what that horse is going to be in the end, which movement it's gonna have, what expressions it's gonna have. What windfalls will come your way in the course of doing that piece. So, I'm always willing to try the piece again and again and again just to see what will come of it. And I've noticed, in the course of doing that over and over, the process grows, there's a growing process . . . the horse changes, there's more animation, maybe more lifelikeness, there's a livingness comes out of it.

Indeed, every piece that Skip makes differs from any other. His experimental renditions of animals such as horses must be created from logs with a two-to-three-foot width. Each horse, for example, will have to have tucked legs, but the expressions of the horses will vary greatly, as will their positions—from rearing to galloping to running in pairs (plates 35, 14, 15, 16). His artistic study of the horse has expanded from a sculpture of one horse to that of a band of five to seven horses on the gallop, made from one log (plate 17), and reliefs with running horses galloping toward the viewer in three dimensions from a flat background (plate 26). That evolution reaches a pinnacle in a sculpture of twenty-seven horses, for which Skip moved out of the constriction of the log's width by using its length (plates 19, 20, and 21). This ability to grow in new directions is part of what

makes Skip Armstrong a unique artist and adds to his mystique as a man whose life has been anything but ordinary.

A Local Character

Skip is known to his friends and neighbors in Sisters as a local character capable of many feats, narrow escapes, and trickster antics. Dave Goodwin has known Skip since he first arrived in Sisters. Having been told that he knew a lot of stories about Skip, I arranged an appointment to videotape him narrating them. The tape reveals Dave's great admiration for Skip as he relates some of the trips they have taken together and recounts Skip's unusual feats.

Dave keeps a scrapbook of pictures of their trips and of Skip's major sculptures; he enjoys telling stories about Skip's road adventures, embellishing the tales to fit his idea of Skip as an eccentric and talented person. Many of the stories deal with Skip's role as a tireless, driven creator. During the following tale, we could hardly contain our laughter:

> There's stories of him cutting in the back while Susie's driving down the highway—he's still workin' on them. In fact, that happened goin' out toward Boise. On the desert. Susie's in there drivin', he's in this big van, it's hot, summertime. And so he stripped down to just his shorts, and he's back

there, and a cop comes up behind him and he's moving this big heavy piece around in there and the whole thing is, the van is moving around . . . and there's smoke billowing out the back 'cause his chainsaw's smoking. And so the cop gives the siren and the red lights and pulls Susie over and he says, "What in the world is going on in this rig?" And she goes, "Oh, my God, you'll never believe it." So he goes around and opens the door, and there's Skip in there working away . . . because he has to have this piece ready for Boise when they get there. And then, you know, the cop finally realizes, "Well, hey, this isn't very safe."

Perhaps the most famous tale is that of Skip flipping over a van load of pieces en route to California. Skip disclosed the following incident to Susan over the phone one evening when she was at my house in Eugene. I recall that we all were impressed with Skip's antics and relieved that he had dodged danger once again. By the time Dave has told it a few times, the tale recounts another miraculous escape:

> He was going down to . . . to an art show. . . . And he had quite a load. I think he had ten pieces of beautiful horses and eagles and cougars and everything that he wanted for that show. And he had driven from Sisters

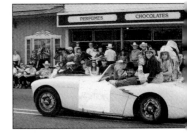

Skip in the 1994 Sisters Rodeo Parade, an annual Sisters event. Daughter Chelsea waves to the crowd. Note the black walnut horse mounted on the hood.

24

in his van down to the Salinas area and he was so tired he just couldn't function, so he pulled off the freeway, on Highway 101, and found a nice comfortable, safe spot, he thought, to park his rig and to sleep. Now Skip likes to sleep upside down. He likes to put his head down on the floor and his feet up in the air. Many times when we're driving, like [to] southern California, I'm driving and he's sound asleep with his head down on the floorboard and his feet up in the air. And people think it's kind of weird when I drive by, but, what can I say, this is his way of getting the blood energy into his head, and he's thinking while he's sleeping in a way. So, he's in this position and he woke up—sometimes he wakes up with a start—and his arm bumped the gear shift. The rig started to move and he didn't realize it. He laid back down and he thought, "Oh, my God, this rig is moving." And it's pitch black out there and the freeway's right there. So he didn't know what to do. He couldn't get it back in gear and he couldn't reach the brake 'cause he's upside down and kinda backward. And he's got this whole load of beautiful art in this van. And so he did pull the wheel . . . away from entering the traffic where eighteen-wheelers are comin' at seventy miles an hour. And the next thing he knows it just went over this embankment and just rolled down. Everything in it went upside down. He says, "Now, when it ends up, I'm sitting upright." All four wheels are there and he's in perfect position. And he says, "Dave," he says, "you can not believe the sound of black walnut and bronze crunching, horses' hooves, horses' tails, and horses' heads in this slow motion of movement when everything I have is . . . just being torn to pieces." And he said it was just a mess. Anyway, the cop comes and he didn't dare tell the cop, "This is the way I sleep." He says, "I was trying to fix a wire under the dashboard." He says, "Well, I've never seen anything like this in my life." So, anyway, they got a tow truck and it pulled it back over on its wheels, and he lost a full tank of gas. That made him unhappy. And, of course, the oil ran out of the engine; he had to put oil in it. But the truck ran fine. He went on about his business. I think he had to put a new windshield in. Busted the windshield out. So that's Skip. Every time he goes on a trip, stories like this come back.

When Skip travels on vacation with Susan and their daughters Chelsea and JaciRose, he sometimes goes to the San Juan Islands, where he continues his childhood love of sailing and works on restor-

ing an old wooden sailboat. Susan pointed out that Skip, even on a break, was still working in wood—just on a different object. One innovation on the boat is a platform addition for chainsaw sculpting off the stern.

The House

Skip is always working creatively, whether it be on his boat, the animal pieces, or the family's house. The house and its architecture are the focus of stories Skip tells; the house is symbolic of his self-image as a man with the ability to create ingenious forms:

When I'm here working I'm a hundred percent here for the workshop. Although I splint off and splinter off energy here and there to do projects, I love building. I love designing and building houses, at least this house. . . . This house grows, this is a sculptural entity. . . . I live in a sculpture. I created this in the same sense that I create a sculpture in wood. I come at the wood sculpture without any clear, total idea as to what it's gonna be, but I work with it. And this house grew the same way. I thought about the spaces, I lived in them and then we went at it one day and just started building. One room led to another design. Kind of an organic growth. No plans. Just the space looked and felt good and that's what we built.

But this house started, interestingly enough, with a little shack in the woods here, twelve by sixteen. That was the first Sisters house. No running water. No nothin'. No electricity. And I lived in that for six years. . . . That twelve-by-sixteen got expanded one day to twenty-four-by-sixteen. Now that was a big house [laughs].

Living in the quiet of a forest on a daily basis, Skip began to think about how to bring that sense of the outdoors inside the house. An instant decision created an entirely new house. He explained:

One day I just got tired of living in a space where I couldn't see the mountains. Rather than cut the trees down, I came up with this great idea of going up above the trees. I thought, "These trees aren't that big. We'll be able to build above it." So I took the chainsaw out, cut the roof off one day—you know, this is how things happen around here, just spontaneously, you hit it hard, you run with it. So I cut the roof off, went up to the woods here in the high country, and got four fifty-foot logs, brought 'em down. Now I wasn't measuring fifty, it's just that I happened to come across fifty-footers and happened to cut 'em fairly uniformly, the same length—there was no plan. And so I brought them in and set them up, four logs fifty feet high in the air, and just

started building up 'em. I kept building in order to see the mountains, and I kept adding story after story until I got the view that I was looking for. And it turned out that I had to go all fifty feet, fifty-five feet up in the air before I got that panoramic view that I knew was out there (plate 40).

So this house really is a growth without floor plan. Just happened, floor by floor. . . . The local building inspectors, they weren't exactly excited about the idea of somebody building a five-story house.

After the tower on the house was built, the original first story burned down. Skip remembers that as "an infamous day." Although the fire department saved the tower, the main living quarters on the first floor were gutted and the fire revealed Skip's idiosyncratic building style—one which took no account of codes. The county refused to let Skip and Susan continue to live in the house, so they lived in an old converted school bus until Skip could meet the standards:

And one of their criteria was you could not have anything more than a three-story house and it couldn't be more than thirty feet high. And here I had already built a five- or a six-story house, fifty-five feet high. . . . And finally one day I thought I came up with a real winner,

and it was that we were going to call this two basement stories and three ground up stories, and in order to accomplish this I was going to bury the first two floors. And then we were going to measure from the top of that to the top of the roof and it was going to be thirty feet.

The burial of the first two floors was never finished, but scooping up some of the earth in front of the house produced a cavity that Skip later used to create yet another form—a pond (plate 41).

For Susan, life with an artist is sometimes like living in a "constant whirlwind," but it's never boring:

If he's not creating a sculpture, which is when you can really see the creative process, it's something else. It's like the pond has to be bigger, a new room on the house, anything little or small —he's always creating something. . . . I just feel like I'm always in momentum, which is really fascinating. . . . It can be kind of overwhelming, too.

Keeping the shop area and the house separate provides two different domains, making it possible for Susan to live within the drive of creativity. Skip comes up to the house for lunch and breaks, and his daughters visit him in the shop, but the two spaces are far enough apart so that the noise of the chainsaw and the high

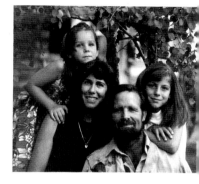

The Armstrong family: *left to right,* JaciRose, Susan, Skip, and Chelsea.

level of activity in the workshop don't intrude on the peacefulness of the house.

Performance

In addition to his concentrated work in the somewhat remote workshop, Skip delights in demonstrating his work to others in a larger setting. After sculpting in the center of town, Skip began to participate in the local crafts fairs that are popular throughout the West. Here, friends and neighbors stop by to wish him well, admire new pieces, philosophize about life, and occasionally purchase a piece. As a local person who has "made it," Skip symbolizes the accomplishments of his generation in Sisters. His reputation as an artist has grown, as have the prices of his sculptures, many of which have been sold at galleries. Likewise, his friends have become more successful in their occupations. Some purchased pieces years ago; others are beginning their collections and are now in a position to afford the higher prices. Skip sees this relationship as a progression. "We've all kinda grown together . . . and they watched me growing. It's really a nice feeling, a real family." He noted that the pieces that stay in the community are special to him. Skip's friend John McIntire built his home with twenty-four-foot ceilings to accommodate a large three-eagle mobile piece.

Gallery pieces often disappear without that personal connection: "I lose track—that piece is lost to me Whereas, this is a face, a warm handshake, a look in the eye—it's just so much more satisfying." The fair setting facilitates personal contact between artist and customer; the pieces come "right straight from the creator, the guy who made 'em." The pieces sometimes operate as links in the relationship. In a discussion following a sale at the Harvest Fair, a crafts market held every year in downtown Sisters, Skip observed, "There's a lifetime tied in there with that particular person. Like Mike, who just bought the coyotes, maybe seven years ago had bought a little orangutan from me" (plate 18).

At this same event, Skip displayed a set of dragon doors (plates 22, 23), which he had made for the entry to the new home of his friend Jeff Goodman. Although the doors were not for sale, Skip wanted to display this new work. He received so much positive feedback on the doors that he decided he would make a standing dragon (plate 24). Skip has made other doors: a pine front door adorns Erik and Kiki Dolson's log home in Sisters (plate 25); in John Day, Oregon, Ponderosa Ranch opens with one of Skip's doors (plate 27); and eight-inch-thick mahogany entrance doors grace Broken Top Clubhouse in Bend, Oregon (plate 28).

The fairs raise the curtain on folk art as performance. Skip stages his pieces in an area of the park. From a small log, he

begins roughing in a form. The noise of the chainsaw attracts curious people from all over the park, and they gather about Skip in a circle, each craning over the other to gain a better vantage point. Wood chips fly through the air, cascading around Skip and mesmerizing the spellbound and willing audience. All of a sudden, a form begins to emerge from the log. Skip stops the saw, and the audience applauds as he flourishes his arm and takes a small bow. Interacting with the audience, he asks, "Anybody know what it is?" They shout back, "A bear." The turbulent performance leads to quiet conversations. Friends catch up on recent events. Susan has noted that these shows give "him the opportunity in his own community to share what he's doing and to get the feedback from local people. And he loves . . . talking to the local people and finding out what's going on for them as much as he does showing everybody his work." Often, locals will discuss seeing specific pieces in each other's homes. Fascinated strangers commonly ask about prices, types of wood, how long Skip has been carving, why he started, and where he lives. Much like any performer, Skip converses with those who approach him. After this short intermission, he begins the saw again and once more attracts and amazes an audience.

In the mind of the artist, consumers and their aesthetics cause an inner dialogue, with the artist "interacting" in a performance with the customer, interpreting the already stated desires of a known consumer or the imagined desires of an unknown future consumer. In the park, Skip takes this dialogue to another level, overtly demonstrating that art is a performance. Narrating and singing are easily seen as performances because they are actions; the creation of an object is no different. All of the elements of the creative process merge.

In the "melting" of his mind with the log, Skip's act of creating a piece becomes a performance, and the speed of the chainsaw makes that performance apparent. Skip wants the fusing to be so complete that he "dances" inside the log:

To me, the chainsaw applied to wood, which is a resistant medium, just speeds up the creative and the doing process. There's no stale time there. It becomes a dance. It's an active happening, it's an event, and it captures your whole focus. The drama of it, the speed— you are totally, one hundred percent, focused in the "now." Right there, you're focused on that piece of work.

Just as Skip finds himself working with the log, rather than on it, the chainsaw becomes much more than a tool; it becomes the dancing partner:

The chainsaw seems to be . . . although it's a rough crude tool, it seems to be in harmonics with the creative

speed of the mind. There's a symbiotics goin' on with the speed of that saw and the way it cuts with the way my mind thinks and creates. So we're in a balance, that saw and I . . . there's really a harmonics, you know, a balance in the work. My fantasy, truthfully, is to be able to literally turn off the conscious mind and just look through the subconscious mind and let this chainsaw and I dance.

Multiple Contexts

His art and the "art in the park" demonstrations that Skip gives have been so successful that the art now "performs" in gallery exhibits where Skip performs as well. The galleries have been instrumental in his success, exposing him to large audiences interested in western art. Many celebrities and collectors have purchased his sculptures. Olivia Newton-John, Clint Eastwood, Nick Nolte, Michael Jackson, and David Rockefeller all own pieces.

To Skip, the celebrity status of some of his clients is less important than their appreciation of his work. And each artist recognizes the talent of the other:

Well, I find that these people are people, celebrities or not. . . . They bought the piece and . . . and I gain a lot of credibility in their eyes, and once that happens, we become on an equal footing. . . . For example, Herb Alpert has become really a very personal friend. I grew up listening to Tijuana Brass and I mean he was a fantasy in the world of records. And now he's one on one. I can drop in any time at his studio and go have lunch with Herb Alpert and that's pretty special.

After purchasing a sculpture, film star Burt Reynolds was instrumental in having Skip's work placed in a gallery showing on posh Rodeo Drive in Beverly Hills, California. Skip recalls their meeting:

I was at a show in L. A. at the Biltmore. It was called the Biltmore Celebrity Show—this was years and years ago [the mid-1980s]. . . . Prior to the show opening, it would be open for these celebrities that would come in. And one of them was Burt Reynolds, and he walked around and saw everything . . . in the show and it was quite a treat when he came back to my work and said, "This is what I want." He had the pick of the whole show, of course. He picked a double eagle piece and I had a chance to go out to his house and install it. There his stretch limo was, you know, and I pulled up behind it in my stretch van and [laughing] unloaded this piece.

A Saudi Arabian prince has also purchased a number of pieces. Dave told us, "His work is getting so expensive that he almost has to take it to Aspen, or La Jolla, or Wilshire Boulevard in Beverly Hills to find its ultimate value because there's

Arabian sheiks buyin' his stuff." After seeing a piece in a Colorado gallery, the man called Skip in Sisters. Dave continued:

> He said, "Armstrong, are you the sculptor? . . . I want you to do one for me. I want you to do it and I'll fly up to get it." And Skip says, "Well, these are heavy. That bronze piece weighs fifteen hundred to two thousand pounds. And, um, what kind of an airplane do you have?" And he says, "A 747." And Skip says, "There's no place you could land except Portland." So he says, "You better buy the one there, 'cause there's no way you can get in near my shop with your 747."

Skip finds that his work speaks to people from all over the world, but because wood "is more organic," it speaks primarily to those with a western frame of reference. The galleries that sell his work are ones specializing in western American art. His tale of an encounter with a New York exhibitor reveals regional differences in worldview and thus in aesthetics:

> **I was told in New York . . . years and years ago this was. . . . I went in and talked to him [a gallery owner], showed him some pictures of the work I've done. And he said it was good, but that it was a little naive. Now I didn't know what that meant at the time, but since then I've kinda glimmered that naive is simplistic, not relevant to the world he was seeing.**

> **Because it was . . . an attempt to touch the soul of the horse as a real horse, he thought it was naive. So I thought at that point, "Well, who needs New York City," you know.**

I commented that the man had said Skip's work was naive because that was not his "reality," and Skip replied, "No, and I recognized, you see, in the end, after I thought about it, I recognized it wasn't bad—that 'naive'—that the earth is, in itself, inherently simplistic and naive, if you will. It's organic. Everything organic in that sense is naive."

The West, Skip recognizes, is not the primary place where grand artistic reputations are made. Although he could work predominantly in bronze, he has pieces cast in bronze only for outdoor art or by request (plate 29). Wood, with the natural sphere it represents, is his preferred medium. His pursuit of the rural outlook rather than the urban scene is another indicator of Skip's need to be true to himself. We continued our conversation about these differences:

> **New York City. There's no city on earth that this would feel comfortable in. . . . My success has been phenomenal, but you think of the art world of New York City—that's where the art world is really happening. But I'm not doing this for the sake of fame and glory. I'm doin' it because it seems real to me. That this is**

really my attempt to enrich humanity, to bring us always back to a core reality that we can't lose sight of—and that's the earth and everything that the earth represents.

We talked at great length about the role of the galleries. For Skip, the galleries provide a different way to communicate. The piece sits in a space where people look at art. "And," he pointed out, "the galleries certainly class up a piece and so the piece becomes an art object." The galleries provide exposure in a wide arena. Skip observed, "I think there's a valuable, necessary function that the galleries play in an artist's career and in the public's perception of the art." The type of gallery must match the work:

There's a soul or a spirit in these pieces that animates out of them, but it takes a context that's sympathetic to that soul in order for that soul to shine. Now this sounds all "floaty" and, you know, "wishy-washy," but the context has to be wholesome and organic to connect and display the wood carvings that I do because they came out of a very organic, whole earth context.

Context is a core issue in folk art studies. In what milieu is folklore created? Does that context affect the outcome? How does the context in which folk art is displayed or used change the way the item is perceived? The focus on the object, even with such intangibles as folk songs, stories or riddles, is limiting. Many folklorists, therefore, have abandoned their studies of context in favor of analyzing events and performances. Folk artists such as Skip do produce concrete objects in context, but, like some scholars, Skip calls his own behavior an "event," a "happening," a "dance." On another level, Skip's work highlights how the concept of context may be used as a tool for defining folk versus fine art. Occasionally, folk art is called fine art when it commands high prices and moves from the artist's locale to a gallery presentation. These are the factors Skip uses to classify his work:

Maybe fine art is a nebulous zone. If you put it in a gallery and call it fine art, it becomes fine art. You just put the same piece in a local show where arts and crafts are the dominant theme, then the pieces become more folk art. . . . So, on surface detail, immediately, if these pieces are in the park and I'm doing a chainsaw demo, the immediate assumption is, "It's chainsaw art, blah, blah, blah." Immediately you hit all of the norms for chainsaw art, until you come close, you really start to see the piece, the piece moves for you, it becomes alive. And then it gets catapulted out of that into something else.

Fine art is generally assumed to be individualistic, with the artist displaying his or her own aesthetic, creating a name by

breaking the boundaries of the art that precedes it. Thus, Picasso created his own style, which no other artist has replicated. Folk art, on the other hand, is thought to be imitative, operating within a known aesthetic. One assumption is that such art is "rustic," "crude," "unsophisticated," and repetitive. Actually, folk art is no less sophisticated than any other art, although it does operate within an established tradition and similar objects do appear. The creative process involves the way in which the artist adapts that style, how he or she places a personal aesthetic within the boundaries of tradition. The high quality of Skip's work does not negate its folk art roots. He is creating within the framework of "chainsaw art," a type of art that is prevalent in timbering areas, most notably in northern California, Oregon, and Washington. A carver need not be a retired logger (although such is often the case) to be a chainsaw artist. The creator need only work solidly within the tradition, learning such art informally.

Chainsaw artists exist throughout the West, and they focus on western characters or wildlife. For example, Mert Menge of Pleasant Hill, Oregon, creates such figures as squirrels, fish, herons, raccoons, and bears in various poses, from large stalking single creatures to whimsical bears climbing a pole. Don "Grandpa" Colp of Oakridge, Oregon, carves totem poles, horses and eagles, miners and cowboys,

and other "remnants of the American frontier West" (Klass 1993). Like Skip, he performs at shows. Even in regions beyond the Pacific Northwest, chainsaw art has become iconographic of what historians call the abstract and imagined West (Cronin et al. 1992).

I asked Skip how he viewed his own art, what he would call it, if he had to label it.

Well, I would label it sculpture . . . even though it's wood and it's carved. When you utilize line and form as your dominant subject, rather than strictly subject, then it becomes sculptural. Sculpture utilizes line.

Skip also sees himself as part of the chainsaw tradition, although, like all artists, he recognizes how his work differs from that of others. Movement is a key divergence. The muscles in Skip's animal sculptures propel them. Observers are always struck by this sense of action. "Independent of context, they'd see line and form and shape and movement and tension, and they'd see sculpture," Skip explained.

Dancing Inside the Log

Audience is very important to Skip. Whether he exhibits in a gallery or in the park makes little difference to him:

Ultimately, it's just people connecting with people. And I think it's important to connect wherever you can with people. There are people at the local crafts shows that would never consider going into a gallery. And I think that what I'm doing is exciting. And it warrants being shown in all different kinds of contexts.

That excitement is palpable in the sculptures and the man who creates them.

As Skip increasingly builds an international reputation, his relationship with buyers has come full circle back to his own shop in Sisters. Local folks invite Skip to look at spaces in their homes and discuss possible sculptures. Clients wander out to the workshop. One not only helped select the log, he regularly comes out to watch the progress of the piece. Solidly situated in Sisters, Skip is creating art for public places, imprinting his artistic vision throughout its source—central Oregon. A ponderosa lava bear stands at Bend High School, having been carved in front of spellbound students from a ten-foot-high stump where a dead tree once grew (plates 30 and 31); a rearing horse stands guard at Sisters High School; and horses race down from the high country in a wall mural relief at the Bend Welcome Center (plate 26).

At the fairs, Skip occasionally displays a sculpture of a woman with a butterfly, a personal piece based on his wife (plate 38).

Not for sale, it "lives" in the Armstrong house, as do many of the animals. Rarely sculpted, humans act to resolve the opposition between animal and human, or nature and culture. In one, a woman and a wolf blend seamlessly (plate 39). In another, a barely perceptible Indian rides intermingled with seven wild horses as one moving spirit and body (plate 32). A large branch jutting out from a black walnut log too heavy to move inspired the rearing horse, and the rest of the sculpture followed. Despite the complexity, Skip nonchalantly remarked that it wasn't that difficult. All he had to do was eliminate everything from the log that didn't resemble seven horses and one Indian.

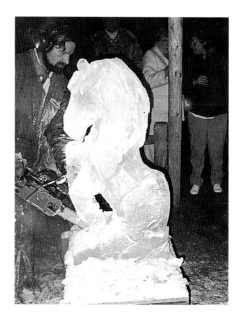

Skip carves an ice horse at a Christmas party.

34

In the "deer dance," a monumental piece that captures the amalgam of man and animal with the dance (plate 33), Skip expresses his ideas about balance, harmony, and the dancing together of the natural world. A herd of deer dance into human forms wearing deer hides and heads and then dance into men compelled onward by the spirits of the deer. The deer and the dancers, created from an ancient log serving as a time line for that movement forward, blur into a chain of men and deer dancing in a liminal spirit world.

One year, Skip was asked to carve an ice sculpture by a neighbor who had seen him sculpt ice in front of Dave's office—an established Christmas tradition for the two friends. Lit by a single spotlight, the ice gleamed, its cold transparency contrasting with the blackness of a crisp winter night. The chainsaw commanded everyone's attention. The drama, the thrill of danger, and the speed of carving the ice opened up the door to the dance:

I'd like to be able to dance inside the log . . . to be unbounded. However, the medium of wood inherently is bounded. It's bounded by a finite mass, and so, if my feeling is to be unbounded, I want to pull the medium to its own limits and beyond those limits. . . . The culmination of . . . that idea happened . . . when I took a chainsaw to this ice sculpture—this block of wood—and there the media had no resistance . . . as fast as I could think,

the saw could execute, to the point where the whole process [snaps fingers] occurred in a short span of ten minutes. I mean it was a blitz of emotion, of energy—it was an energy blitz. It was like a dance and that's what the chainsaw allows. It allows you that creative moment of thinking . . . translated immediately into the act of creating. There's no delay.

Out of this "blitz," a horse of ice glistened against the darkness. Amid shouts of "That's amazing," Skip realized his dream—to dance inside the sculpture.

Always searching for balance—in life, in art, and with the chainsaw—Skip realizes that balance by dancing inside the log as the log yields the dance on its surface. That dance may be as fleeting as the ice sculpture, as tangible as the deer dance or as metaphoric as the dance of movement in running horses, the muscularity of a stalking cougar, the rippling sleekness of the otter, the graceful curve of a heron, or the swooping wings of an eagle (plates 34-38). Armstrong's sculptures celebrate his own rhythm and the rhythm in a line.

The dance makes it clear that the creative act is what is meaningful:

The focus shouldn't be on the chainsaw. The chainsaw is but a tool. And what a man does with the tool, that's the point.

References

Bronner, Simon J. 1985. *Chain Carvers: Old Men Carving Meaning.* Lexington: University Press of Kentucky.

———. 1986. *Grasping Things: Folk Material Culture and Mass Society in America.* Lexington: University Press of Kentucky.

Cronin, William, George Miles, and Jay Gitlin. 1992. "Becoming West: Toward a New Meaning for Western History." *Journal of American History* 80: 3–22.

Ferris, William. 1982. *Local Color: A Sense of Place in Folk Art.* New York: McGraw-Hill.

Fife, Austin E. 1988. *Exploring Western Americana.* Ann Arbor: UMI Research Press.

Glassie, Henry. 1989. *The Spirit of Folk Art: The Girard Collection at the Museum of International Folk Art.* New York: Abrams.

Hall, Michael D. 1987. *Stereoscopic Perspective: Reflections on American Fine and Folk Art.* Ann Arbor: UMI Research Press.

Hemphill, Herbert W., Jr. 1976. *Folk Sculpture USA.* Brooklyn: Brooklyn Museum.

Johnson, Jay, and William C. Ketchum, Jr. 1983. *American Folk Art of the Twentieth Century.* New York: Rizzoli.

Jones, Michael Owen. 1987. *Exploring Folk Art: Twenty Years of Thought on Craft, Work, and Aesthetics.* Ann Arbor: UMI Research Press.

———. 1989. *Craftsman of the Cumberlands: Tradition and Creativity.* Lexington: University Press of Kentucky.

Jones, Suzi. 1980. *Folk Art from the Oregon Country.* Salem: Oregon Arts Commission.

———. 1977. *Oregon Folklore.* Eugene: Randall V. Mills Archive of Northwest Folklore, University of Oregon Press.

Klass, Kayla. 1993. "Carving History: The Chainsaw Sculptures of Don J. Colp." Randall V. Mills Archive of Northwest Folklore, University of Oregon.

Lipman, Jean. 1948. *American Folk Art in Wood, Metal, and Stone.* New York: Pantheon.

Musello, Christopher. 1992. "Objects in Process: Material Culture and Communication." *Southern Folklore* 49: 37–59.

Roberts, Warren E. 1988. *Viewpoints on Folklife: Looking at the Overlooked.* Ann Arbor: UMI Research Press.

Sherman, Sharon R. 1979. *Kathleen Ware: Quiltmaker.* 16mm film. Eugene: The Folklore Program, University of Oregon.

———. 1991. *Spirits in the Wood: The Chainsaw Art of Skip Armstrong.* Videotape. Eugene: The Folklore Program, University of Oregon.

Vlach, John. 1981. *Charleston Blacksmith: The Work of Philip Simmons.* Athens: University of Georgia Press.

Vlach, John, and Simon J. Bronner, eds. 1986. *Folk Art and Art Worlds: Essays Drawn from the Washington Meeting on Folk Art.* Ann Arbor: UMI Research Press.

Yocom, Margaret R. 1993. "'Awful Real': Dolls and Development in Rangeley, Maine." In *Feminist Messages: Coding in Women's Folk Culture,* ed. Joan Newlon Radner, pp. 126–54. Urbana: University of Illinois Press.

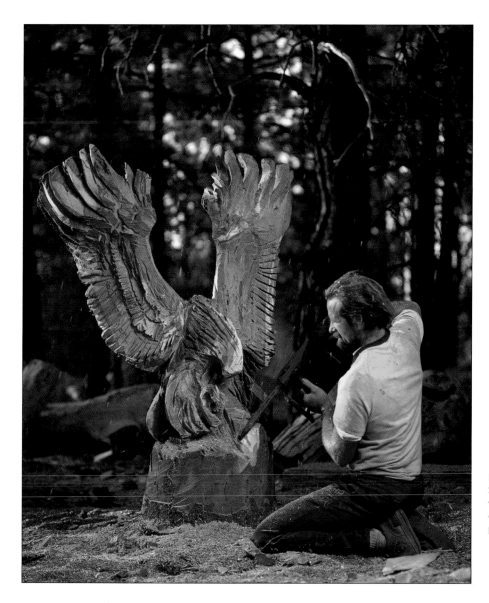

PLATE 1
Skip roughing out an eagle with a large chainsaw. The early stages of his work take place outside.

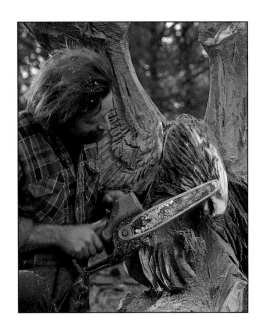

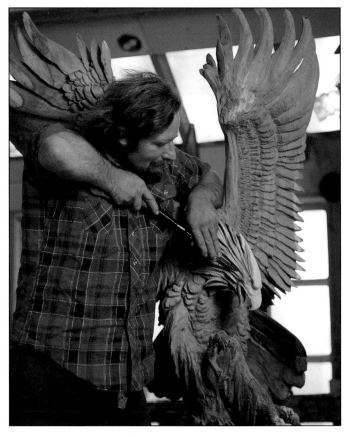

PLATE 2
A later stage of the eagle sculpture in which a smaller chainsaw further defines the lines.

PLATE 3
The piece is moved into the workshop for what Skip calls the "accents." This detailing animates the sculpture.

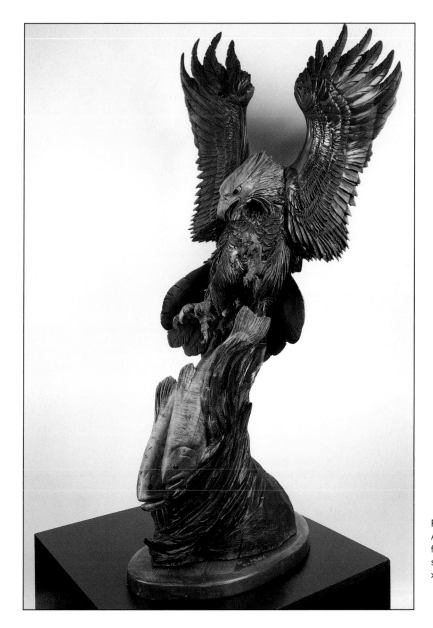

PLATE 4
An eagle, in its finished
form, about to grasp the
salmon. Black walnut. 7' x 3'
x 2'. 1993.

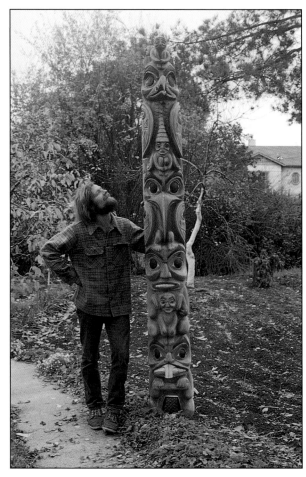

PLATE 5
A totem pole (detail) that Skip patterned after the first one he made at Spirit Lake. Cedar with paint applied. 15' high. 1978.

PLATE 6
Skip with totem pole in 1978.

40

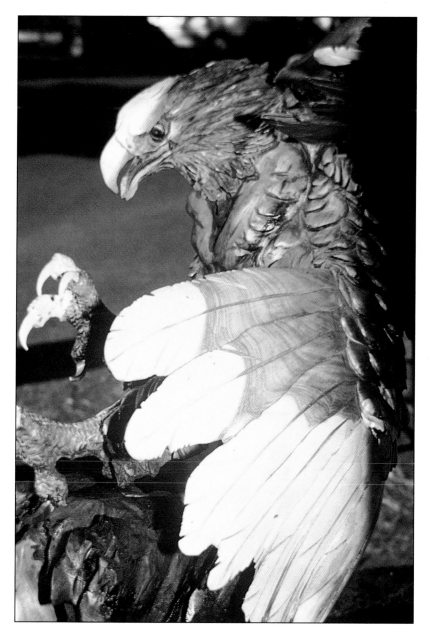

P L A T E 7
Eagle on display in the Village
Green, Sisters, Oregon.
Black walnut. 1989.

41

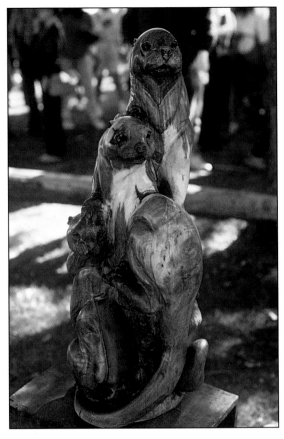

PLATE 8
The sea lion is one of Skip's initial pieces. Redwood, 1974.

PLATE 9
Four otters. English walnut. 36" x 18". 1989. Watching otters inspired Skip to create a sculpture that followed a curved line rather than the linear form of the log.

42

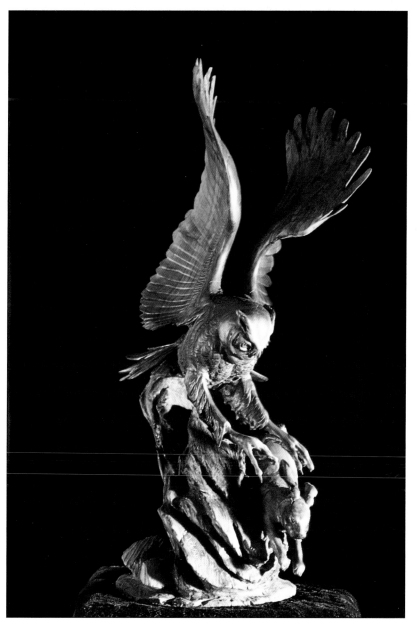

PLATE 10
Owl capturing a rabbit.
Compared with plate 11,
this piece shows the artist's
development in the direction
of greater realism. Black
walnut. 1981.

PLATE 11
Owl. Canadian cedar. 1978.

43

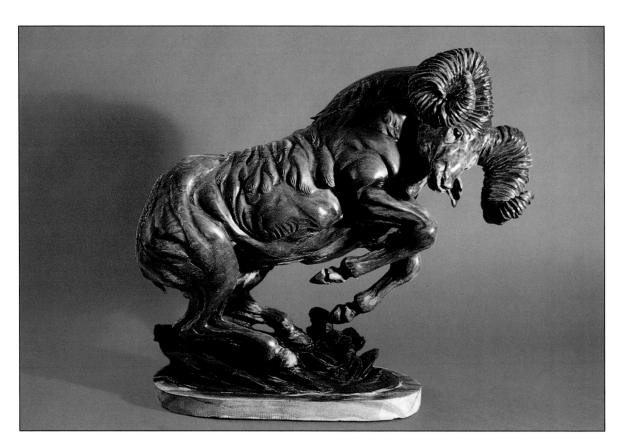

PLATE 12
Rocky Mountain bighorn
ram. Avocado wood. 24" x
30". 1989.

PLATE 13
Detail of a horse's head
before the final accents are
made. In process, October
1993.

45

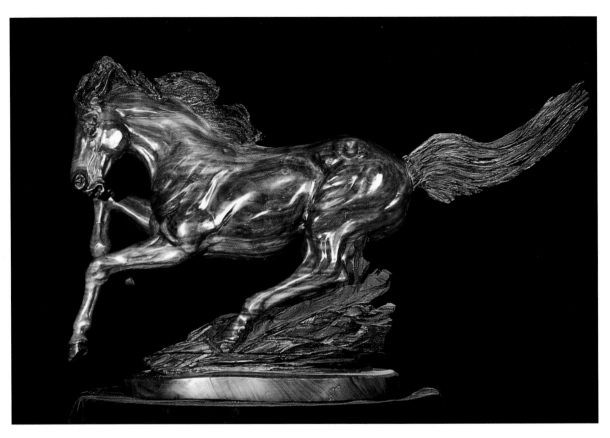

PLATE 14
Galloping horse. Black
walnut. 1990.

46

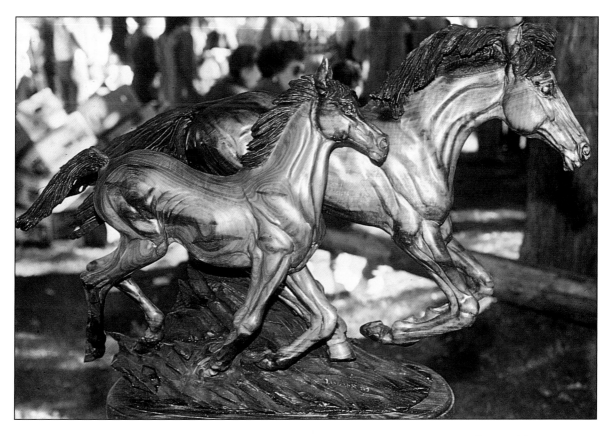

PLATE 15
A mare and her foal moving
side by side. Black walnut.
1989.

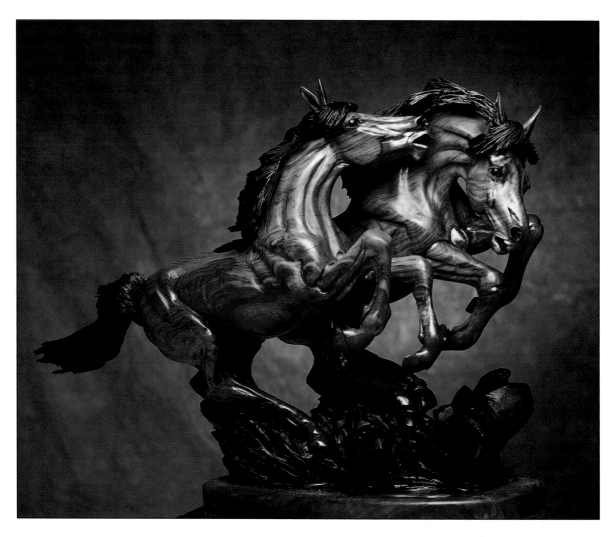

PLATE 16
Two horses, one nipping the other. English walnut. 48" x 23" x 18". 1993.

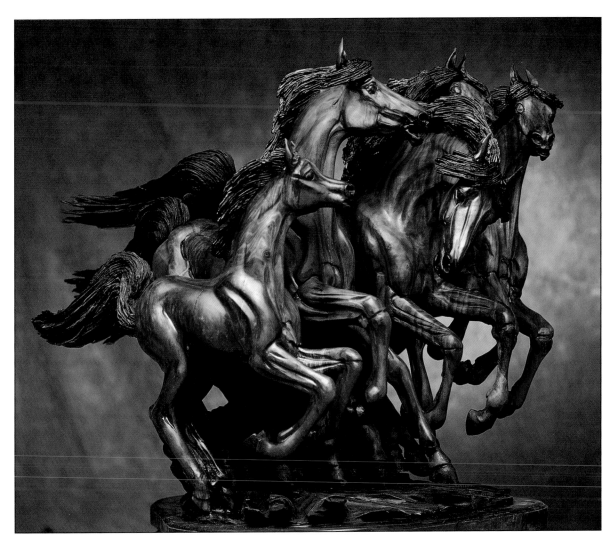

PLATE 17
A pony running with the herd. English walnut. 48" × 33" × 32". 1993.

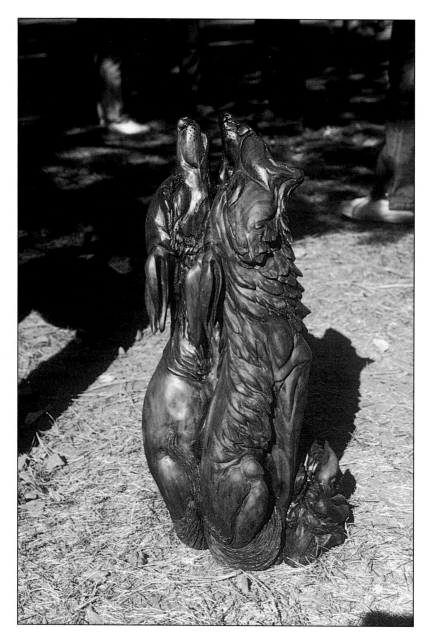

PLATE 18
Coyotes howling in unison.
Black walnut. 1989.

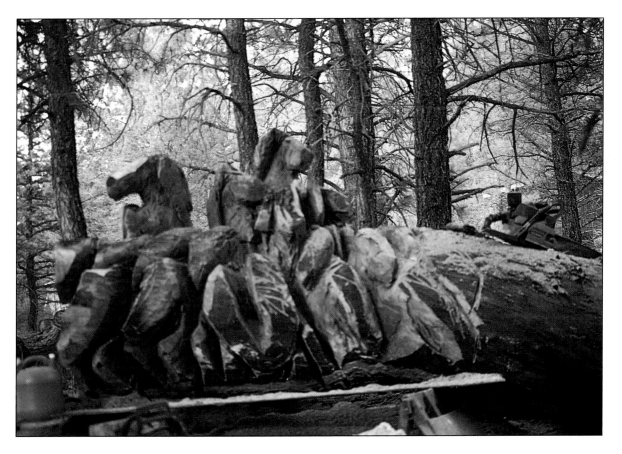

PLATE 19
The roughed-out stage of a
piece that will have twenty-
seven horses and a rider.

51

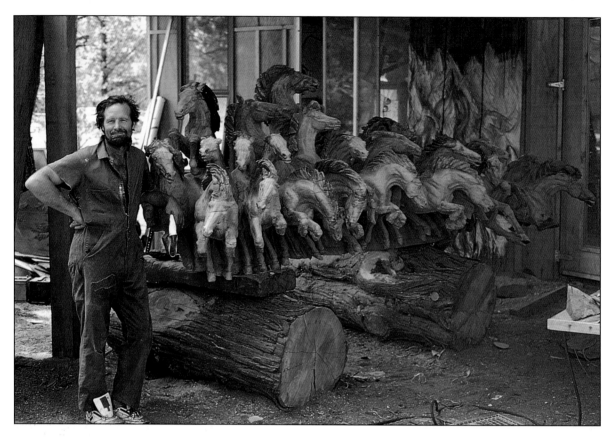

PLATE 20
The twenty-seven-horse
piece approaching comple-
tion next to the shop. July
1994. In Skip's execution of
this form, he used the length
of the log.

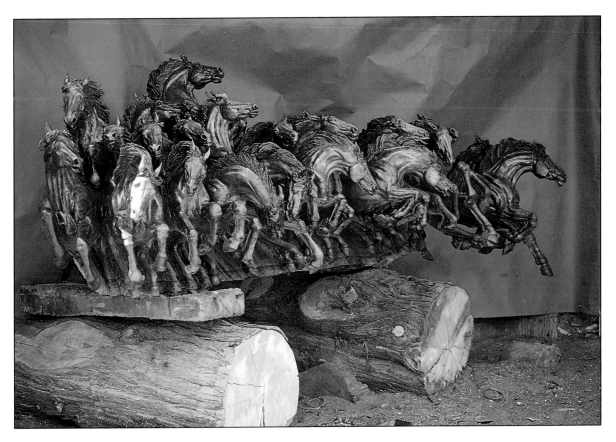

PLATE 21
Twenty-seven horses,
completed sculpture. Black
walnut. 12' x 5'. August
1994.

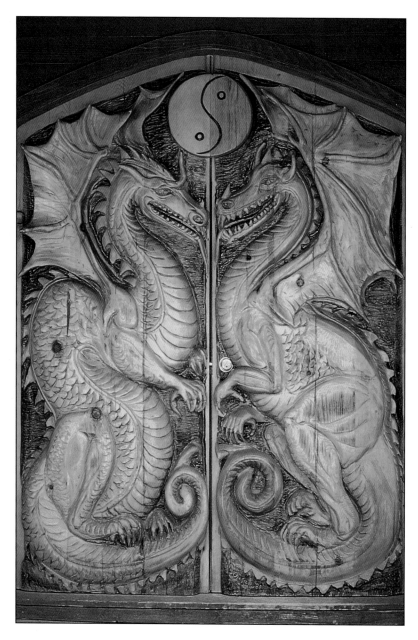

PLATE 22
Dragon doors with yin/yang
decoration at Jeff Goodman's
home in Sisters, Oregon.
Sugar pine. 1989.

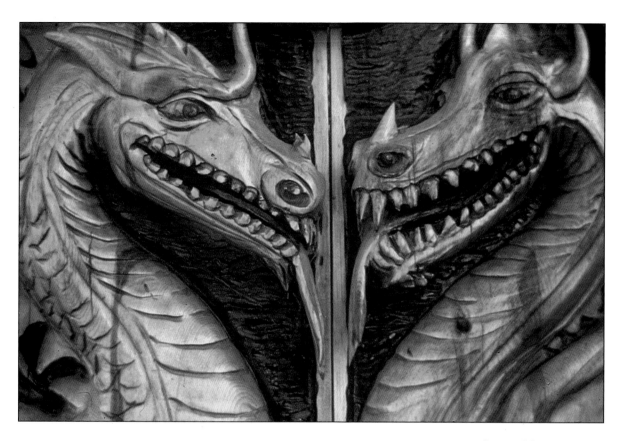

PLATE 23
Detail of dragon doors in
plate 22.

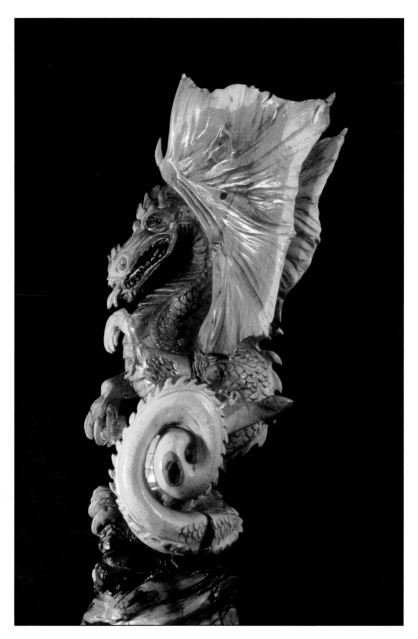

PLATE 24
Standing dragon. Juniper.
4 1/2' x 2'. 1990.

56

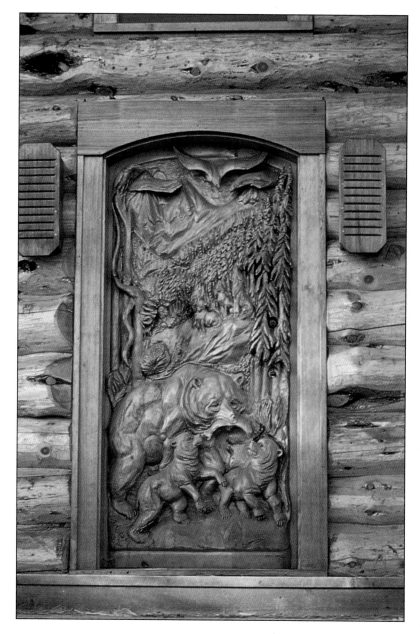

PLATE 25
This door, showing a bear
and her pups preparing to
eat a fish as birds soar
above, adorns the entrance
to Erik and Kiki Dolson's
home in Sisters, Oregon.
Pine. 7 1/2' high. 1988.

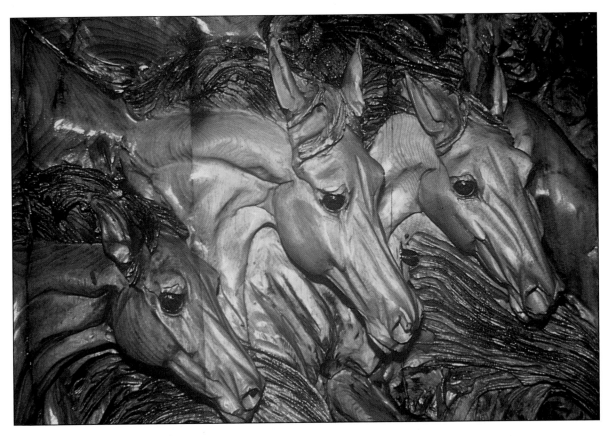

PLATE 26
Detail of wall relief at the
Welcome Center of the
Chamber of Commerce in
Bend, Oregon. Pine. 1989.

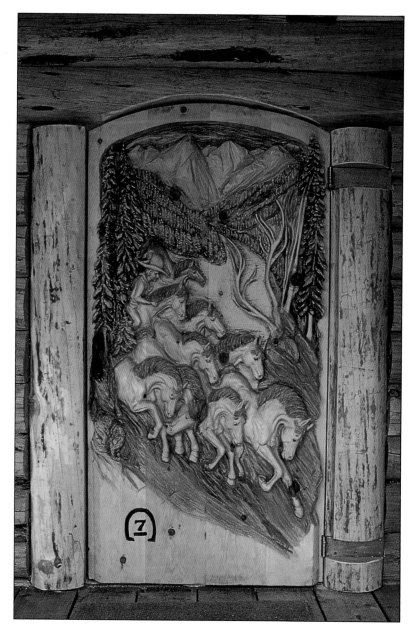

PLATE 27
On this door at Ponderosa
Ranch in John Day, Oregon,
horses are being herded
down from the high country.
Sugar pine. 1993.

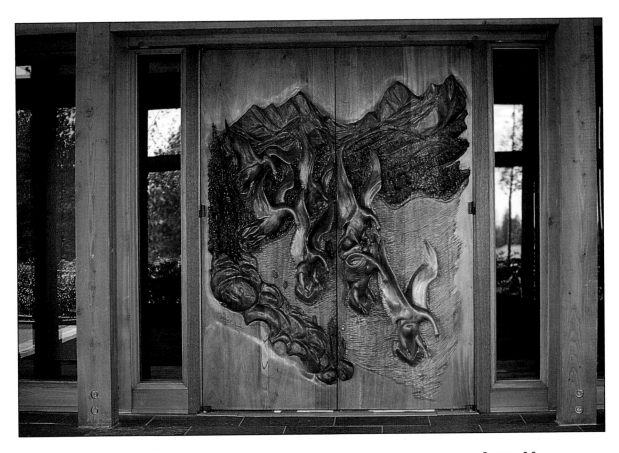

PLATE 28
A gaggle of descending
geese appears on the doors
at Broken Top Clubhouse in
Bend, Oregon. Mahogany. 8"
thick x 7' high. 1994.

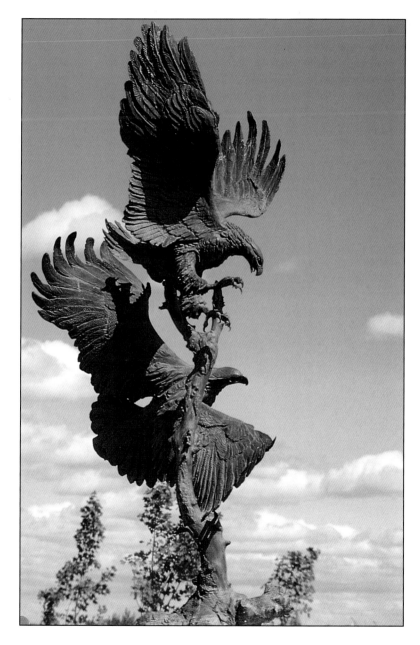

PLATE 29
This sculpture of two eagles
in flight fighting for a salmon
stands at the entrance to
the Redmond Municipal
Airport. Bronze. 15' high.
1981.

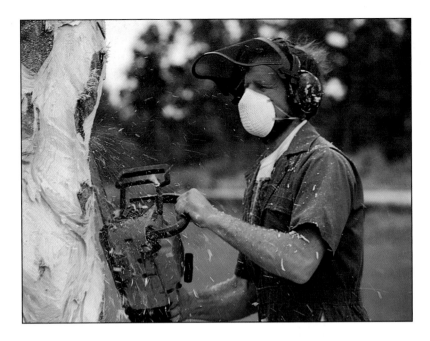

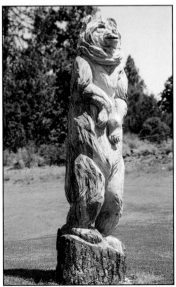

PLATE 30
Skip, donating his services to the community, creates a 10' high lava bear for Bend High School.

PLATE 31
Lava bear. Ponderosa pine. 1994.

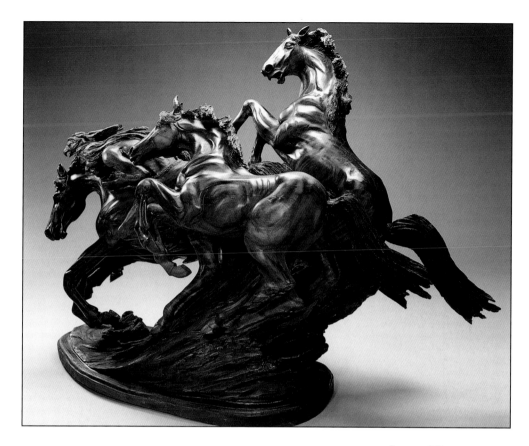

PLATE 32
This sculpture conveys what Skip calls his own "imagination of the West." Seven wild horses run with an almost invisible Indian rider. A large branch jutting out from a black walnut log too heavy to move became the rearing horse, and the rest of the sculpture followed. Black walnut. 6' x 4 1/2' x 3'. 1990.

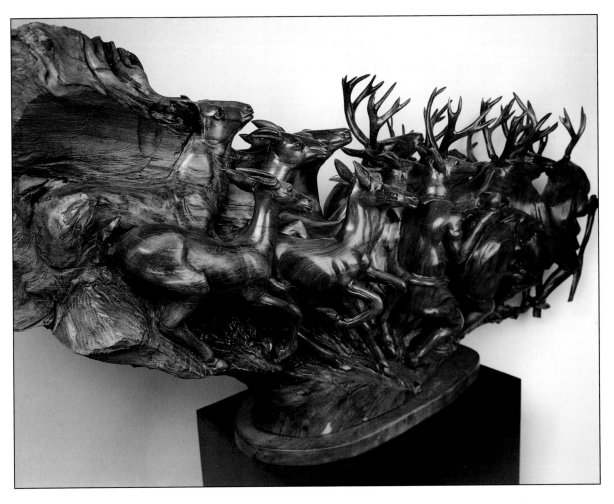

PLATE 33
The spirit of the deer infuses
the deer dancers who are
transformed from animal to
human. English walnut. 8' x
4' x 2 1/2'. 1993.

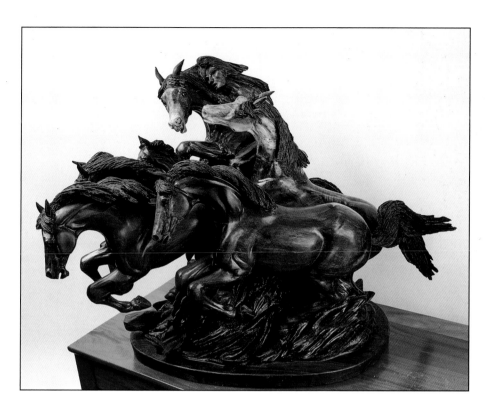

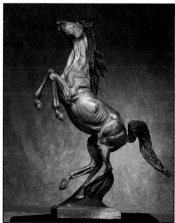

PLATE 34
Blending in with the back of
the highest pony in the herd
is an Indian wearing a cere-
monial animal headpiece.
Black walnut. 5' x 3' x 2'.
1993.

PLATE 35
Rearing horse. English walnut.
4 1/2' x 30" x 18". 1993.

65

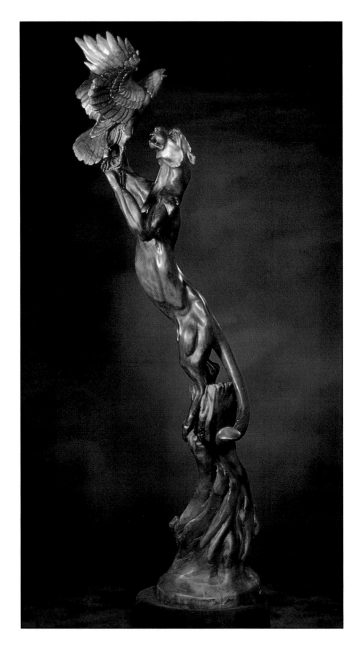

PLATE 36
A coyote with ensnared bird
represents the harmonic
balance of life for Skip. Black
walnut. 1988.

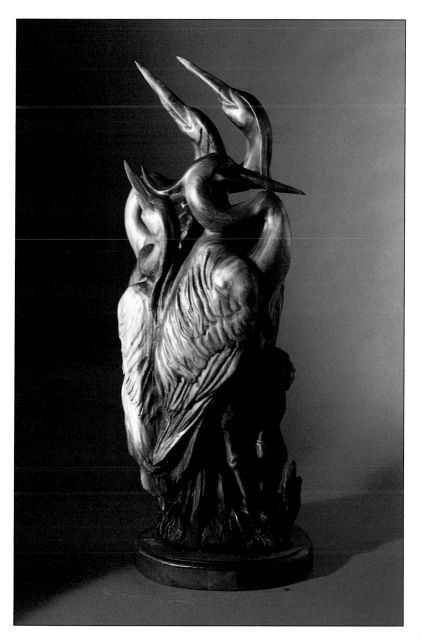

PLATE 37
Herons. Black walnut. 33" x
18". 1991.

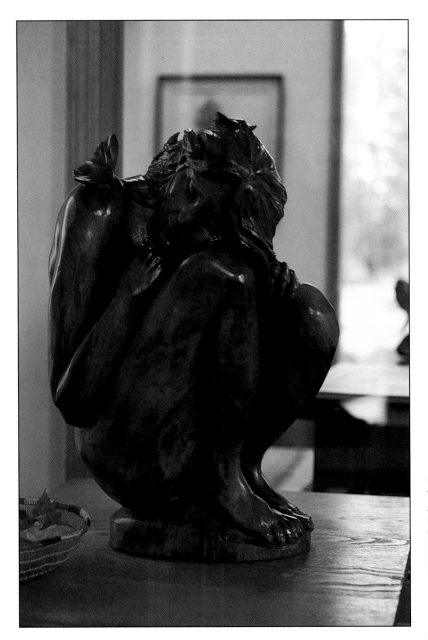

68

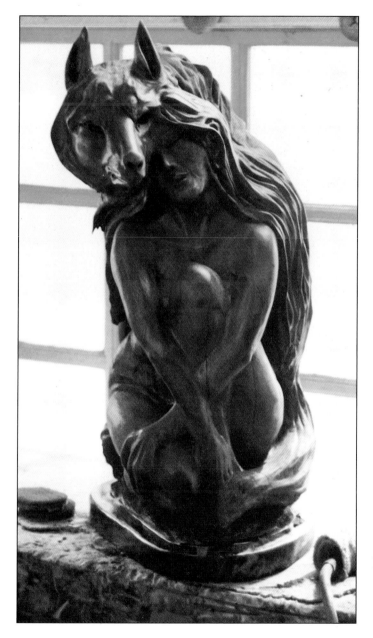

PLATE 39
A woman and a wolf seem
to fuse. Black walnut. 1994.

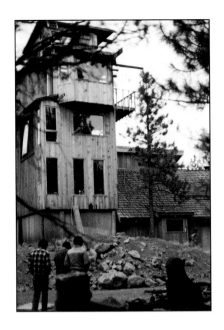

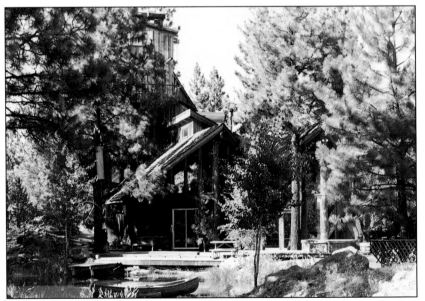

PLATE 40
Side view of the Armstrong house in 1985. The tower has five stories and is fifty-five feet high. Scooped-out earth piles up in the foreground, leaving space for a pond.

PLATE 41
Front view of the house in 1994. Skip sees the house as an ever-changing sculpture. Note the pond, now completed.

70

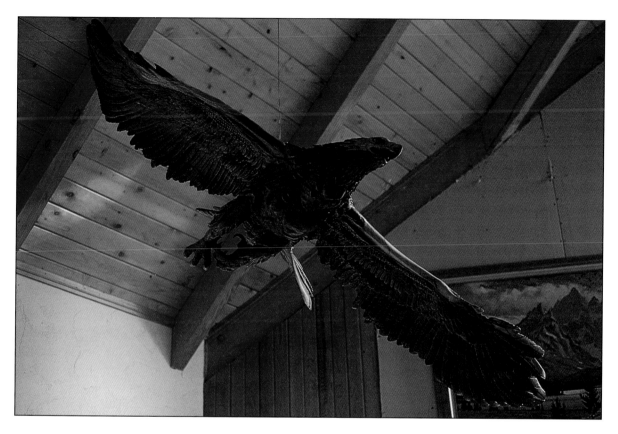

PLATE 43
View from the end of the
road leading to Skip's house.